MEANS OF ESCAPE

Throughout my work I present two states of social consciousness that are in continual cultural opposition. I state that the dominant social consciousness, the one that prevails throughout the institutional fabric of society, is deterministic and based on the possession of objects and their social authority. There is an institutional, authoritatively mapped out social consciousness, its ramifications affect everyone, and in my work it is contrasted with a social consciousness of self-organisation that expresses mutuality and personal creativity. For I see that within every person there is the potential of creative self expression, but that this is inhibited and repressed by the authoritative determinism that underpins the physical and social composition of the everyday world. Perceptions and understandings are laid out for us to follow, about how we should respond and behave in a world that is presented as if it cannot be changed, not only dictating our identity, but also our social position.

In a world dominated by the power of objects, self organisation is a counter consciousness that frees the individual from the constant pressure towards conformity and passivity. Counter consciousness is the creative response of people to express their own sensibility and psychology. The presentation of these two different, and culturally opposed ways of perceiving reality, has directed both my working procedure and the visual composition of each work. The concept of self organisation is not only symbolically represented in my work, but the actual process of its internalisation by the audience involves them in acts of cognitive self organisation, for they construct their own means of escape.

Symbols

It is a fundamental part of my working procedure to search for and identify symbols that are residual in the culture and which will powerfully represent, to an audience, the two opposed states of consciousness I have just described. First I look for obvious symbols of the deterministic, object-based consciousness, and then I uncover balancing expressions of people's self organisation and statements of self identity. My starting point is the physical manifestations of our culture's institutional idealisations and self projections. These have a crucial power in society for they are emulative and set the cultural norms and beliefs.

I see that the 'new reality' of the tower block, or slab block, associated with the municipal housing estate, or the monolithic office block, are manifestations of the authoritative idealisations of the professional: the planner, the architect, the financier, etc. As such these structures impose a pressure on the occupant's psychology and behaviour by their very physicality that is consistent with the social consciousness of their creators. Originally the tower block was seen as the modern way to live, the building of the future though, as is now commonly recognised, the very fabric of its structure reinforces an object-based consciousness in a way not foreseen by the planners. It isolates occupants, not just from interactions with each other and from the surrounding world, but by giving them a feeling of detachment, of introverted passivity. The tower block is a highly dependent structure, requiring a great deal of physical maintenance, social services, and resident's compliance with codes of conduct to even function as intended, and when these conditions fall down, so it rapidly deteriorates. Consequently I have often used the typically grey, concrete, rectangular form of the tower block as a powerful symbolic context that not only embodies society's idealisations and its self-images, but also the very problems and conflicts inherent in the social consequences of those idealisations.

Contexts

At the same time as I am searching to identify symbols that represent the object-based consciousness I am revealing simultaneous, and contrasting, expressions of counter consciousness. Expressions that are made in defiance of the institutional environment are particularly important, but these may initially be difficult to detect, small gestures such as a potted plant outside the front door, or holiday postcards pinned on the wall by an office desk, can take on an enormous significance. The symbols of counter consciousness that I see as a counter balance revolve around self-organised contexts that have been established by people as a vehicle for their own expressions of creativity. Such contexts are not only hard to identify but are difficult to access as, by their very nature, they exist undercover in the inaccessible, forgotten corners of society, often directly repressed and usually alienated from their surroundings.

A context for the manifestation of counter consciousness that I found very powerful as a balancing symbol, were the areas of wasteland adjacent to municipal housing estates. While the grey concrete, uniform blocks of the housing estate represented, for the residents, institutional dependency, isolation and passivity, the tangled mass of the wasteland symbolised the opposite. For residents could engage in activities there that expressed individual and community identity. I found that all sorts of objects from the estates had been taken into the wasteland by residents to agency different activities that were outside the norms of the dominant culture, expressing their alienation and escape from that culture.

Thus contexts are a hidden place for personal expression, their very self creation is an extremely important cultural act, which has implications for everyone. However, the establishing of a context or capsule is still dependent on the dominant culture, for it has to co-exist, being reliant on it as a source of material. Here lies the really creative act, which requires objects from the dominant culture, with their attendant pre-determined function, to be transformed into an agent for manifesting the counter consciousness. The set determinism given to the object by the dominant culture is broken by it being appropriated by the creators of the counter consciousness, becoming an agent for self-organisation.

The monolithic mass of the tower and slab block is a powerful symbol of the institutional idealisations of the dominant culture.

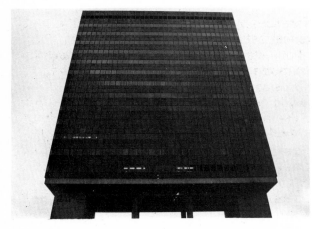

MEANS OF ESCAPE

Stephen Willats

1984

Rochdale Art Gallery

Published as a catalogue for the exhibition 'MEANS OF ESCAPE'
7th July - 4th August 1984
Rochdale Art Gallery, Esplanade, Rochdale, Greater Manchester

Published by Rochdale Art Gallery, Esplanade, Rochdale, Greater Manchester, July 1984
Telephone 0706 - 47474 Ext. 764
Copyright Stephen Willats and Rochdale Art Gallery. 1984.
Designed in Association with Patsy Mullan.
Assisted by the Arts Council of Great Britain.

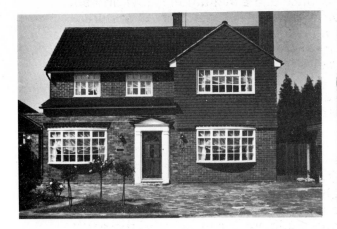

An authoritative symbol of 'success' within a property-based hierarchy of social values.

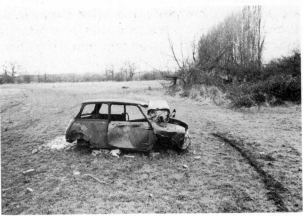

The transformation of the dominant culture's symbols in the wastelands, into symbols for a counter consciousness: Cars were driven into the wastelands by the glue sniffers from the adjacent estate and set on fire, then left as monuments.

One of the most important and articulate contexts in which transformations are made uses the cover of night to screen itself from society. I found that the private clubs which sprung into transitory existence in London at the beginning of the 80's were another powerful symbol of self organisation, and thus they have formed the context for a group of my recent works. For the members were the organisers and vice versa, the clubs being private in that they were meant for friends, again another context for the expression of community and self-identity. While each club has its own special identity (Model Dwellings - futurism; The Anarchy Centre - mohicans), the common motivation to create community reflected the origins of members who largely came from similar faceless housing estates that were symbolised in my work with Pat Purdy and discussed later in this catalogue. The day represented normality for the night generation, a boredom and pre-determinism they wanted to escape from, so the works I made contrasted day with night. The housing estates, tower blocks, where the night people lived I associated with the day, seeing their individual domestic environments as a capsule, isolated and surrounded by an alien world, and I contrasted this with the spontaneous freedom found in going out to the private clubs at night. Here the tacky, matt black walls of the private clubs forms the context, the means of escape, and in my works the audience make similar transformations.

Objects

Different objects have particular importance to different groups of creators of counter consciousness, and in each of my works about particular people I identify those objects that are central to them personally. These identified objects actually become part of my work so as to confront the audience with the reality they are viewing. Objects that are central to the audience's world are symbolically mirrored in the actual objects that have been incorporated into my work.

Audience

My works present the audience with a layer of references by depicting the same reality through various media forms. Each layer of references sets up disparate cues so that there is not a pre-formed, legislated, single view, but instead the disparate references are self-connected by the audience to create their own model. The audience make their own journey, their own transformations, between the cues associated with each state of consciousness; from the day to the night, the housing estate to the wasteland, from the conscious to the unconscious. My organisation of the layout of the references from which the work's symbolic world is formed I consider essentially a parallel process to the audience's process of de-constructing and internalising those disparate references into a coherent model. Thus thee active, self-organisation required from the audience in their cognitive relationship with a work is in itself a creative act, an expression of counter consciousness, and in this way the ideology that is its governing force is externalised. The work is the audience's means of escape.

A SOCIAL METHOD OF WORK

The making of a work always involves me in a social process with a person, or persons, who I see as symbolising a particular, enclosed reality. Initially I will develop a purely theoretical model from which the concept of an individual work derives, I then decide on the type of physical location that I think will embody the model. The next step is to carry out a reconnaissance, to select actual locations and then establish contact with the individuals there.

While I am exploring the location I have chosen two parallel orientations are taking place: firstly the conceptual model that I have developed for the work is changing as a result of my becoming familiar with the area, secondly my explanation of the proposed work to people locally increases my contacts. I explain to people my ideas and the kind of person I would like to participate in the making of a work, if they do not become involved themselves they usually suggest someone else they know who I could contact. That my introduction is thus by familiar people is extremely important to the potential participant's confidence in the idea. Several meetings are then arranged when I can discuss with the participant my work in general and the particular work I want to make. From this point the way in which a work is developed radically differs from most contemporary art practice, for instead of making it about someone, viewing them as an object, I make it directly with them as a mutually based co-operation.

It is fundamental that there is a binding connection between the theoretical and conceptual model of a work that I make; its realisation and its presentation. The concept of self-organisation is not the only message contained in all my work, but it is constantly manifest in a participant's involvement during its making and the audience's relationship during its reception. The actual reality of the participant, which is ordered and encoded by them into the work, is to be re-ordered, deconstructed by the audience as a parallel to their own experiences.

The entrance to the Cha Cha Club was an old railway arch, at the end of a narrow alleyway, underneath Charing Cross Station:- The Club for people who don't need to pose. You can use the night as cover, as a cloak to be who you want, to be yourself, without anyone hassling you. A recent phenomenon in London is the private club, set up by a new generation who want to escape into the night, and to express themselves in a way that is difficult in the straight world of the day. The Cha Cha Club captured the spirit of this new generation's attitude perhaps more than any other, where anything was possible if your attitude was right. (S.W. 83)

Inside the Cha Cha Club

As a result of meeting members of the Cha Cha Club while making the work 'Are You Good Enough For The Cha Cha Cha' I became aware of the extent of the night world that has recently emerged. I went on to make most of my works over the last three years with people that had been to the club at some point.

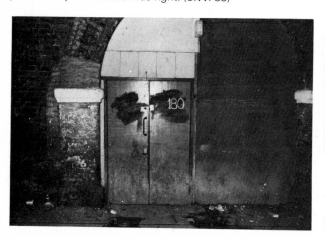

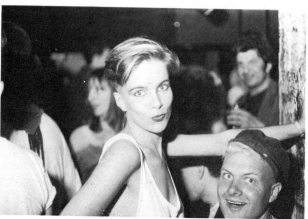

Julie working at my studio, handwriting quotations from tape recorded interviews I had made with her onto the panels of 'Living Like A Goya'.

Arranging objects Julie had given me for 'Living Like A Goya'.

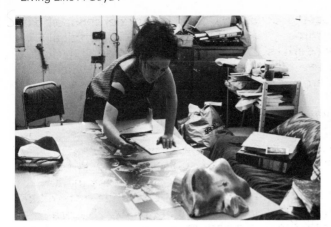

Having agreed on a plan of approach with the participant I start documenting the topology of the reality to be represented in the work. I make a number of tape-recorded interviews with the participant which are then transcribed to provide texts that can be used directly in the work to express their attitudes, beliefs, etc. With their active guidance I photograph their environment, the objects within it, and the participants themselves engaged in whatever activities they consider reflect their way of life. While I am doing this documentation, which usually takes several months, I also ask participants to collect together objects which they feel are important to them. These objects can be very special and personal or just household rubbish, sometimes just a few things are collected while others may get together sacks of items. I do not just visit the participant, they also need to come to my studio, especially when all the documentation has been accomplished and the work is physically taking shape.

With the help of the participant I always devise a question; I consider the question as a basic stimulus to interaction between people, and in my work it is addressed specifically to the audience. While various elements, such as photographs, handwritten texts, objects etc., confront the audience with the actuality of the participant's world, my question is their access point around which subsequent relations to the work revolve. It is the bridge for the audience between their framework of personal references, and the participant's references that have been encoded into the work. Earlier works of mine specifically represented realities that were familiar to people such as offices, factories, houses, flats, etc., with which they felt able to identify personally; but now I am confronting the audience with 'capsulised' worlds, selected precisely for their inaccessibility. These 'capsules' are tangential to the social norms and values of the dominant culture and, in all probability, are alien to the audience, but they overtly manifest the concepts of self organisation.

Each work has its own history, my relationship with a participant being personal and different in each case, even though very much the same procedure is followed when making the work. Sometimes just a few visits are made to my studio and I work mainly at the participant's place, other times a lot of visits are made, it depends on the individual circumstances. However, the work is finally finished only with the approval of the participant, who is free to change what they have done to that point. In the same way that I seek a consistence between the conceptual model and the way in which the actual work is made, I provide a context for it within the exhibition environment during its installation. I paint a large background shape onto the wall to which the piece will be fixed, that will surround it as a reinforcing context. The transference of a work to different exhibition environments is a fact of our object-based culture, but any such movement must inevitably affect the audience's behaviour and their internalisation of the work. However, my background painting is intended to reduce such disturbance.

Tower Block Drawing No. 4 (Organic Exercise series)
1962.
21½ x 31 inches.
Ink on paper.

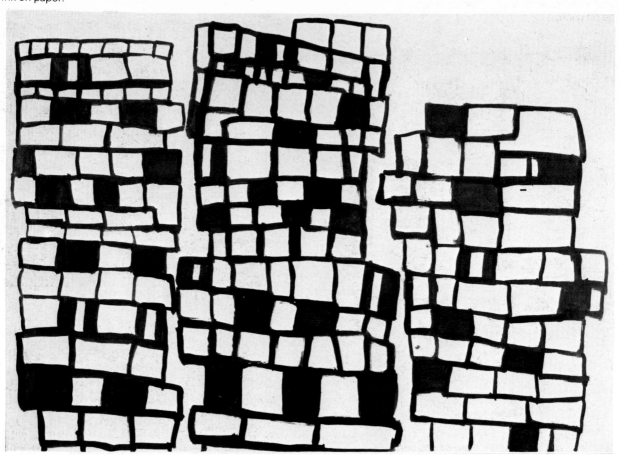

Homeostat Drawing No. 1
1969.
22 x 28 inches.
Pencil on paper.

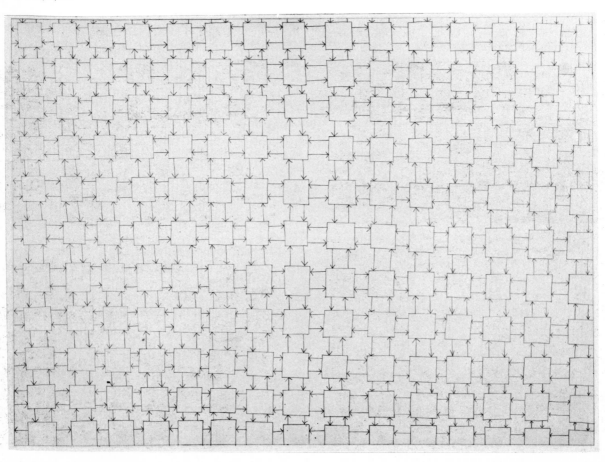

'Man From The Twenty First Century'.
1969/70.
33 cm xx 20 cm.
Two sheets from range listing domestic objects.
Collage on paper.

'Tennis Club Project'
1976.
29·5cm x 20·5cm.
Two sheets from range of twelve listing objects associated with environment of four tennis clubs in Nottingham.
Photographic prints on card.

'From A Coded World'
1976.
51 cm x 59·5 cm.
Photographic prints, Letraset text, ink, gouache on card.

The group.

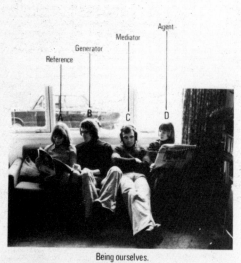

Being ourselves.

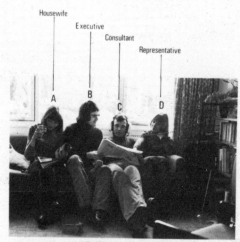

Fulfilling expectations.

References from the contextual present.

Images from a projected future.

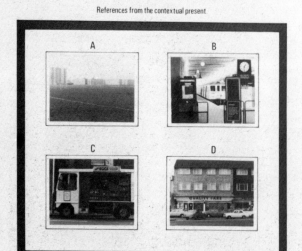

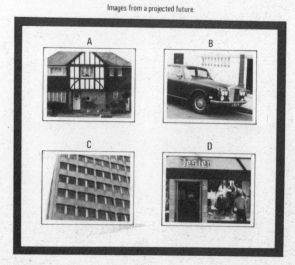

From a coded world.

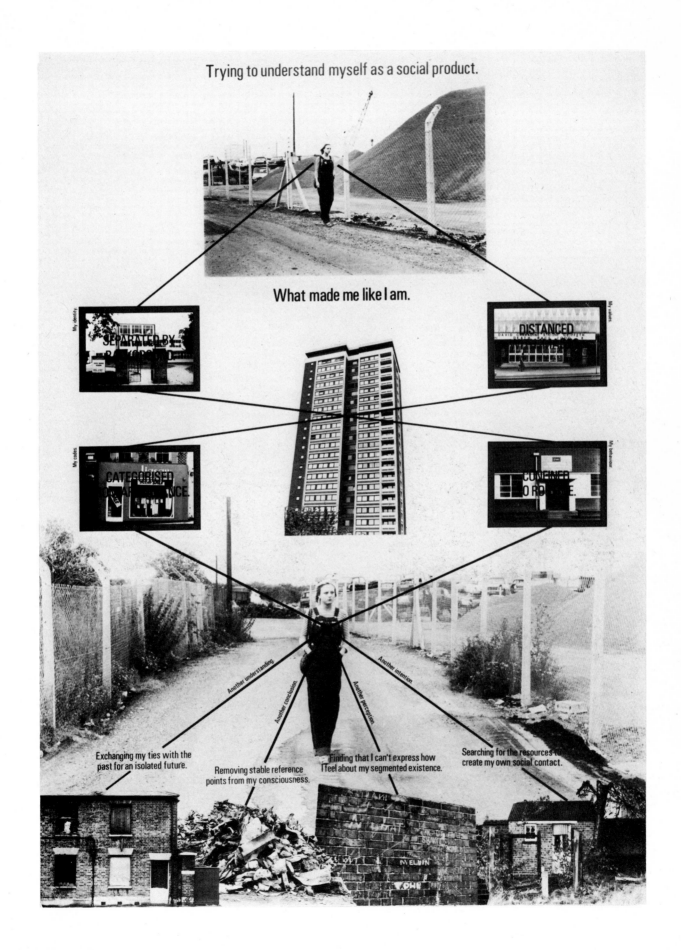

PAT PURDY AND THE GLUE SNIFFERS CAMP

The Avondale Estate at Hayes in West London has formed the context for a number of my works made during the last six years. The estate was built in the middle 1960's and was a product of the Hillingdon Council Planning Department's conception at the time for 'model' low cost, high density housing. It was a conception that has gone disastrously wrong, and now a great many flats are just plainly uninhabitable, and the sole pre-occupation of remaining tenants is to get out as fast as possible.

As with all my works, while I have a general idea of its direction before I meet people, the outcome is always a result of what is mutually established. What transpired from my conversations and later taped discussions with Pat Purdy, was the great importance the wasteland had that lay directly adjacent to the estate. This wasteland had formed the context for my earlier work 'The Lurky Place', as well as featuring in other pieces I have made going back to 1972, so it was already quite well known to me. As a result of walking around the wasteland with Pat Purdy and discussing with her what she did there, I came to realise the central role building camps had for the teenage youth living on the estate. A primary activity in the camps was 'glue sniffing', a can of Evostick being heated up on a small fire, placed amongst a ring of car seats, or discarded tyres.

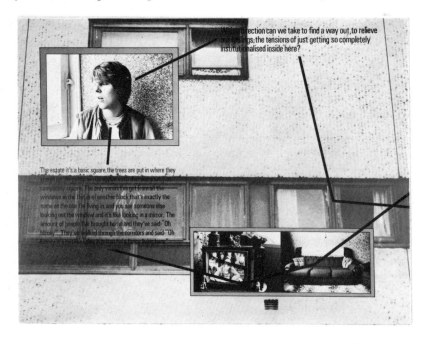

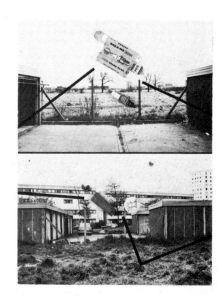

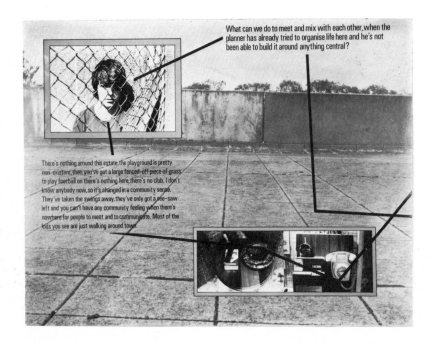

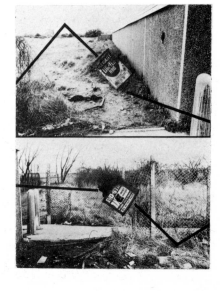

After a number of meetings with Pat Purdy, when I photographically documented her environment on the estate and made a number of tape recorded discussions, the structure of the piece emerged. The work is divided equally between the deterministic pressures emitting from the estate, and the wasteland, which is seen as the context for resisting those pressures by creating a 'counter consciousness'. Having developed the basic structure, I went back to one camp that Pat Purdy was particularly associated with, photographically documented it, and then took away all the discarded objects that I could find there. Instead of, as in earlier works in the 1970's, trying to create a Symbolic World for the audience that was slightly removed from their own reality so that they could make freer conceptualisations by being detached, I felt that current tensions required a more immediate confrontation.
I therefore decided to embody the collection of objects found in the camp directly in the work, and to ask Pat Purdy to write her own quotations straight on to the photographic panels connected with the wasteland. A number of sessions were arranged at my studio, where Pat Purdy wrote her quotations and directed what objects and photographs I should use in the piece. The process of making the work took nine months, and was only finished when Pat Purdy finally gave it her approval.

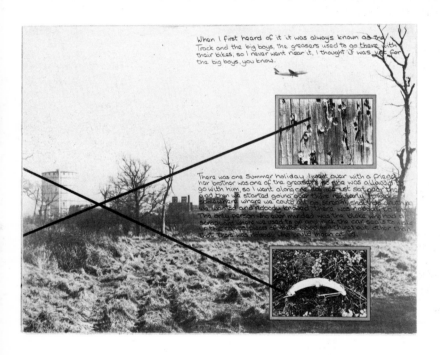

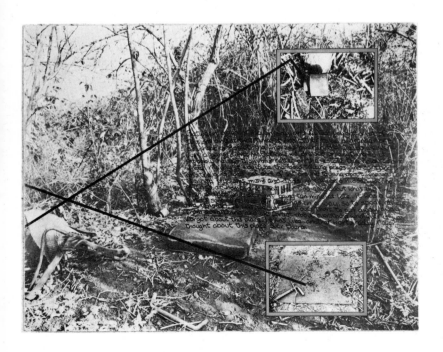

'Pat Purdy and The Glue Sniffers Camp'
January/September 1981.
Eight panels, each 76·5cm x 102cm, and four panels each 66cm x 51cm. Photographic prints, photographic dye, gouache paint, ink, Letraset text, felt tip pen and found objects from The Lurky Place, West London.

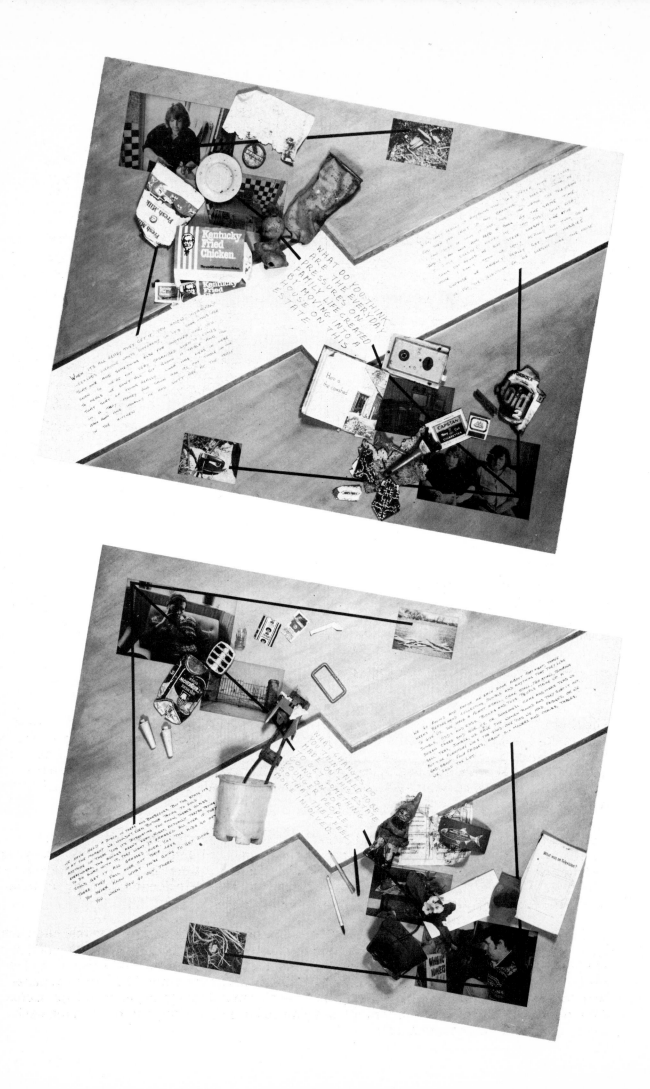

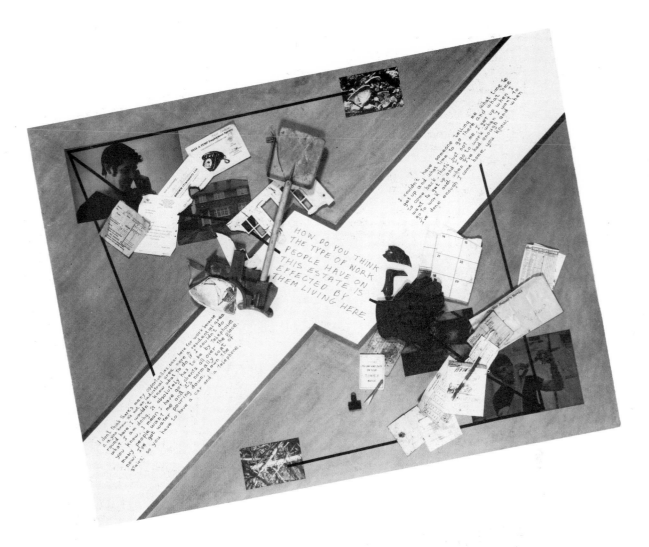

'The People of Charville Lane'
January/December 1981.
Six panels, each 100cm x 135·5cm
Photographic prints, photographic dye, Acrylic paint, pencil, ink and found objects collected by residents of the
Charville Lane Estate, West London.

THE PEOPLE OF CHARVILLE LANE

The Charville Lane Estate built just after the last war by Italian prisoners, reflects the municipal
thinking of the time, for it is made up of small terraced housing constructed around a large
centre circle as an estate focal point. The isolation of the estate by the surrounding wasteland,
and its general setting in an inaccessible part of West London immediately interested me,
as here was a context in which people would have to fight back against extreme social
deprivation in an urban location.

The documentation I built up involved six residents who found different ways to try and
overcome the tension and their isolation, concentrating on different aspects of their daily lives
as follows: 1) Historical. 2) Domestic. 3) Social. 4) Economic. 5) Cultural. 6) Political. Each area of
tension is represented in the work by one board devoted to one resident, this being formulated
as a mutual co-operation between myself and themselves.

The work was physically put together in the front living rooms of the six estate residents, who
wrote out the quotations on each board in their own handwriting, and then later finished at my
studio. These quotations create a direct link for the audience to the resident's reality, and in
order to reinforce the feeling of confrontation, actual objects are embodied into each panel
with the texts and photographs. The objects were also found for me by residents themselves
from their own household environment, or by myself from searching there, i.e. in the back
garden, dustbins, in the street, etc.

'Escape With Me'
July 1983.
70cm x 110cm.
Photographic prints, crayon, ink on paper.

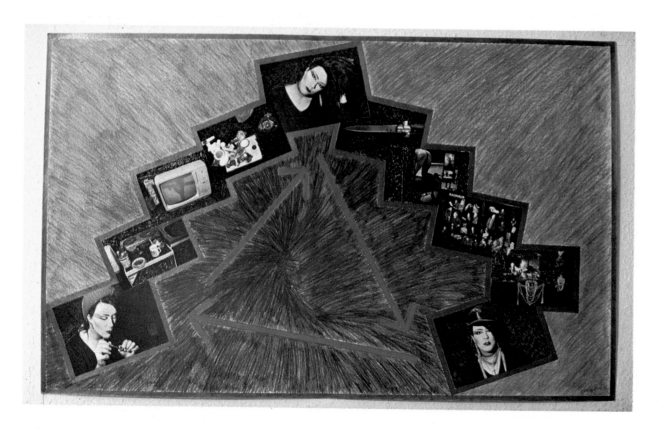

'CAN TWO VIEWS REALLY CO-EXIST?"

Lizzie Grant co-operated with me in the making of a work that centered on her experience of living in an ageing municipal block of flats in Hammersmith, London. I saw Lizzie Grant's own struggle to express herself within the confines of those flats as symbolising the basic fight of everyone trapped within a rigid, unyielding, physical world. For most people, like Lizzie Grant, are forced through circumstance to accept the inevitability of their destiny within the physical and social environment they find themselves, feeling it is beyond their personal ability to change these conditions. Any self-expression is made within what is perceived as normal behaviour, through subtle adaptations to convention or through very discreet manifestations of other values. These self-expressions are personal, contextual in their references and thus to the outsider difficult to detect for what they are: a means of escape. They appear almost hidden amongst displays of normality and conformity.

The work with Lizzie Grant presents what she accepts as inevitable and normal, the reality of her environment within the municipal block in which she lives. In the first panel of the work the block represents the control of Lizzie Grant's life by the dominant culture - the generator of her tensions and problems. Her reaction and fight to establish her own view within that same block of reality as shown in the second panel, is a parallel for the audience in resolving their own struggles with reality.

'Can Two Views Ever Really Co-Exist?'
October/December 1983.
Two panels each 140cm x 101cm.
Photographic prints, photographic dye, ink, Letraset text, acrylic paint, and objects collected by Lizzie Grant from her flat.

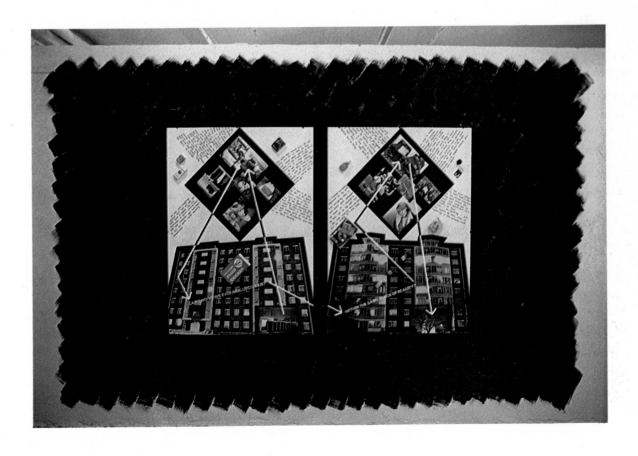

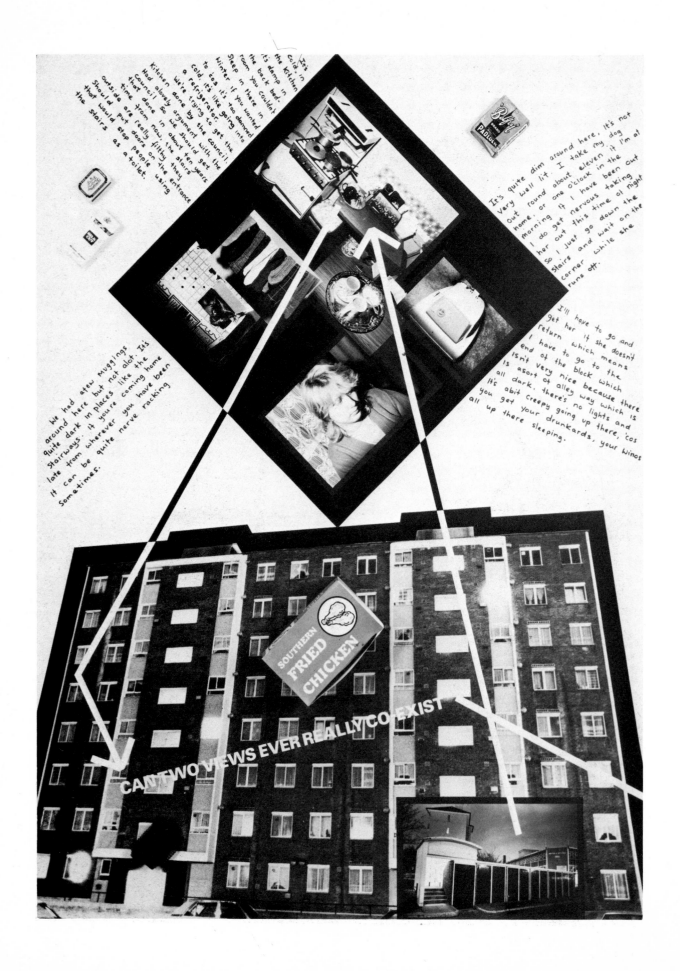

It's cold in the kitchen and the kitchen it's damp in the back bed. Sleep in there room. You couldn't have done in the winter if you wanted to see it's too damned cold it's like going into a refrigerator to get the time from now, the stairs should get done in about ten years Had alway argument with the Council. So i.e. Should put that would put doors on the outside are really filthy they Should the entrance that would stop people using the stairs as a toilet.

We had a few muggings. It's around here but not alot. It's quite dark in places like the stairways. It you're coming home late from wherever you have been it can be quite nerve racking sometimes.

It's quite dim around here, it's not very well lit. I take my dog out round about eleven at night, or one o'clock in the morning if I have been out I do get nervous taking her out this time of night so I just go down the stairs and wait on the corner while she runs off.

I'll have to go and get her if she doesn't return which means I have to go to the end of the block which isn't very nice because there is a sort of alley way which is all dark, there's no lights and it's a bit creepy going up there, 'cos you get your drunkards, your winos all up there sleeping.

SOUTHERN FRIED CHICKEN

CAN TWO VIEWS EVER REALLY CO-EXIST

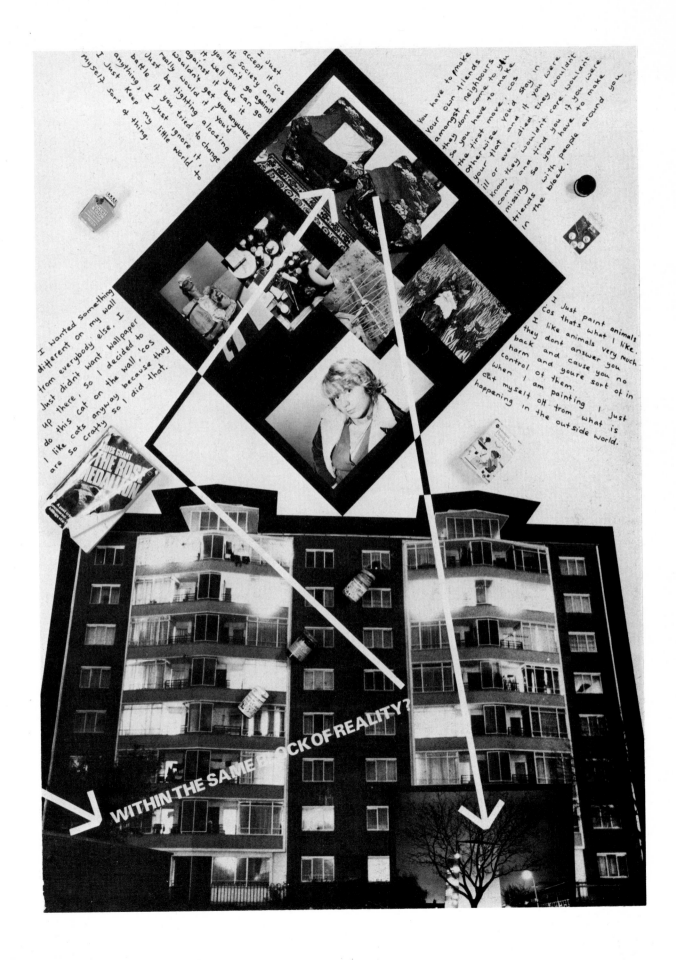

I just accept it cos it's society and you can't go against it well you can go against it but it really wouldn't get you anywhere. Just be fighting a loosing battle if you tried to change anything, I just ignore it. I just keep my little world to myself sort of thing.

You have to make your own friends amongst neighbours, they dont come to you. So you have to make the first move. 'cos otherwise you'd stay in your flat and if you were ill or even died they wouldn't know they wouldn't care. come and find you if you were missing so you have to make friends with people around you in the block.

I wanted something different on my wall from everybody else, I just didn't want wallpaper up there, so I decided to do this cat on the wall, 'cos I like cats anyway because they are so crafty so I did that.

I just paint animals 'cos thats what I like. I like animals very much they dont answer you back and cause you no harm and youre sort of in control of them. When I am painting I just cut myself off from what is happening in the outside world.

WITHIN THE SAME BLOCK OF REALITY?

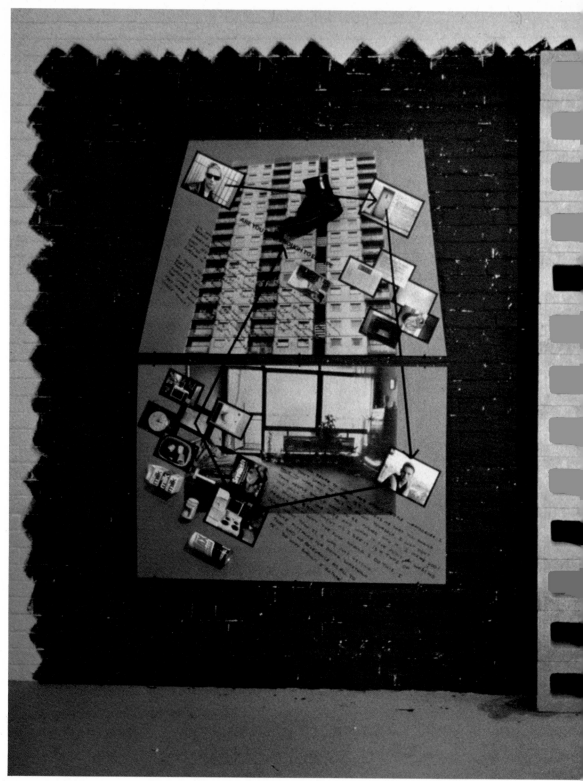

'Difficult Boy In A Concrete Block'
July/November 1983.
Four panels, each 96cm x 145cm. Tower made from concrete breeze blocks. Photographic prints, photographic dye,
Letraset text, ink, felt tip pen, acrylic paint, and objects collected by John from his flat.

'DIFFICULT BOY IN A CONCRETE BLOCK'

The work 'Difficult Boy In A Concrete Block' is divided between day and night. The day is
associated with the physical determinism of the institutional culture, as manifest in the mass of
the tower block, and the night with the psychological freedom of a counter culture based on

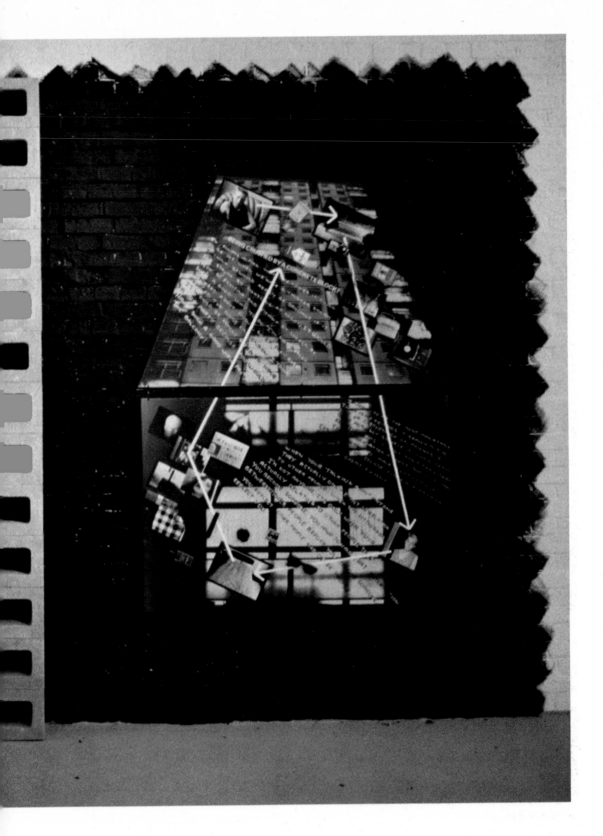

self organisation. The underlying form of the work stems directly from the contrasts in John's life, who co-operated with me in the making of this work, centering it for me on his own reality within the tower block in which he lived. John was associated with the new night culture in London, regularly going out at night to such private clubs as The Cha Cha Club. Like many other members of the night culture, he took up his local council's offer of a difficult to let flat in a tower block, which most of the older residents were trying to vacate as quickly as possible.

John was one of the generation who have grown up to be familiar with the grey concrete surroundings of tower blocks which, though he saw them as a disaster, he also saw as the normal way to live now. Sixteeen floors up in his distanced world his attitudes about his environment were altogether different from older tenants who fondly remember streets of terraced houses.

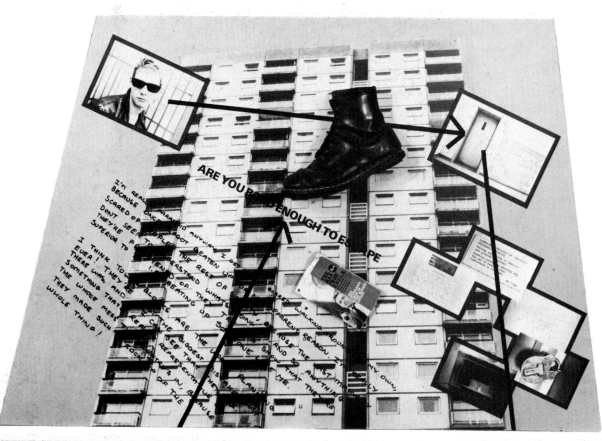

ARE YOU READY ENOUGH TO ESCAPE

I'M REALLY PARANOID ANYWAY I GET SCARED OF ANYONE, BECAUSE DON'T SEEM TO GOT BEATEN UP. THEY'RE FUCKING THE REST OF UNDERSTAND WHAT I'M SUPERIOR TO ...

I THINK TO BE BLOCKS OF SO MANY EVER I THEY'RE BEATING UP SOMETHING THAT THERE WAS, AND ARE THE UGLIEST THE WHOLE MEN THE BIGGEST THEY MADE SUCH REPRESENT THE WHOLE THING!

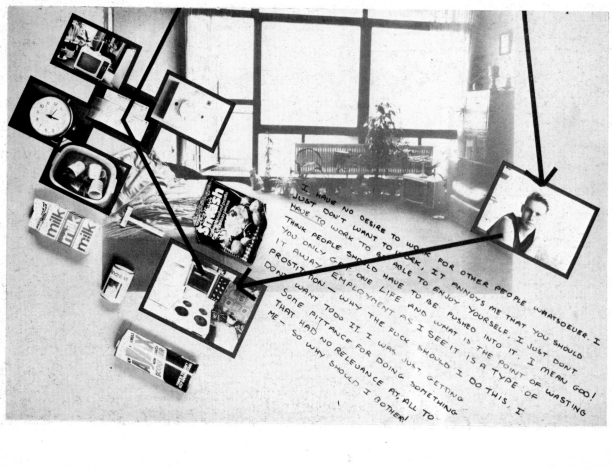

I HAVE NO DESIRE TO WORK FOR OTHER PEOPLE WHATSOEVER. I JUST DON'T WANT TO WORK, IT ANNOYS ME THAT YOU SHOULD HAVE TO WORK TO BE ABLE TO ENJOY YOURSELF, I JUST DON'T THINK PEOPLE SHOULD HAVE TO BE PUSHED INTO IT. I MEAN GOD! YOU ONLY GET ONE LIFE AND WHAT IS THE POINT OF WASTING IT AWAY, EMPLOYMENT AS I SEE IT IS A TYPE OF PROSTITUTION — WHY THE FUCK SHOULD I DO THIS, I DON'T WANT TO DO IT. I WAS JUST GETTING SOME PITTANCE FOR DOING SOMETHING THAT HAD NO RELEVANCE AT ALL TO ME — SO WHY SHOULD I BOTHER!

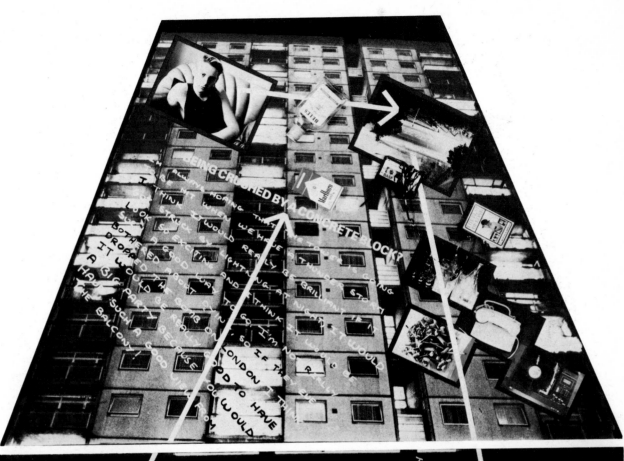

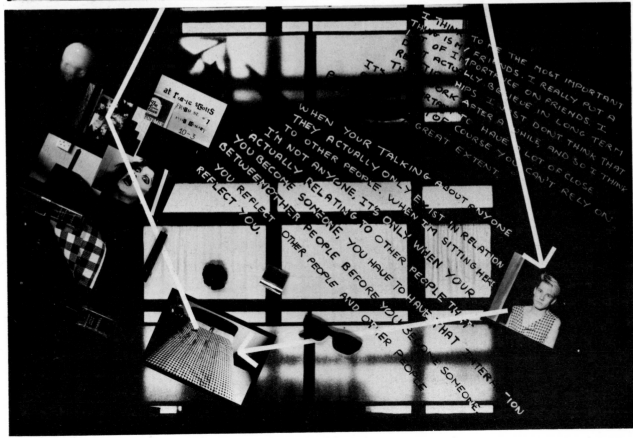

INSIDE THE NIGHT

For an individual or a group to achieve the freedom to move outside pre-determined society it is important that both the context and the codes for the activities there are both seen to exist at a tangent from the dominant culture. For the group the context they find or create for themselves is a capsule in which they can hide from the authoritative control of society, its separation being defined through the setting up of codes that are overtly alien from the dominant culture. So, it is important that the activity within the capsule is self-organised by the group, and is perceived by the group involved as outside society, alienated and taboo. As all the pressure on individuals within a group is to conform to the dominant culture's norms, any resistance to state other values has to be seen immediately to be at a tangent, the new codes are just not presented but are seen as definitely breaking the old ones. However separate and impenetrable the capsule it still has to co-exist with the dominant culture, for it still is connected physically, economically, and ultimately psychologically. This co-existence requires that new codes - those of the group - are projected onto what exists to transform it, and that pre-determined objects from the dominant culture are given a new function within the group. The act of transformation from one culture to another being an active and creative state.

The Night

The night has always been a very potent territory for groups to define for themselves a capsule, to conceal themselves from the prying eyes of the dominant culture. During the night the most visible aspects of the dominant culture appear to close down, and this in itself simply removes the pressures on people to conform to its norms. In the night the all-embracing determinism of today's reality can be temporarily left behind by establishing a community that exists outside 'straight society', with their own special codes and values, to express themselves in the night. In this sense the night provides a general territory, but the specific context used by some groups to define their own capsule are the private clubs that have proliferated in London during the last few years. The clubs are an expression of self-organisation for the individuals running them are from the same community as those that go there. These private clubs are generally only open for friends of the individuals running them, persons from a particular community that display the new codes. The transitory nature of these private clubs is also a phenomenon, for they are opening and closing all the time, requiring a knowledge of the night network to keep up with recent developments. I saw these private clubs as an important expression of the underground culture of now, and as a powerful tangential world that could be embodied in my artwork.

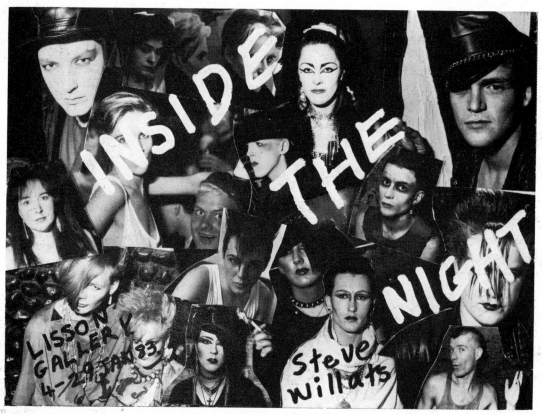

'ESCAPE WITH US INTO THE NIGHT"

'Escape With Us Into The Night' was originally one of four works in my exhibition, 'Inside The Night' (Lisson Gallery, 1982), that centered on different self-organised private clubs. This work concerned one manifestation of those private clubs: an extreme rejection of society's values, an alienation from its idealisations, that found expression in non-conformity and through the display of aggressively tangential codes of dress and behaviour.

The close knit group of Mohicans with whom I made the work, Garry, Liz and Dave, were anarchists who lived only for the psychological, social and cultural freedom they found in their trips out at night, especially to the club, The Anarchy Centre. This display of especially aggressive and socially taboo visual codes, and the angry, tense atmosphere and violent music of The Anarchy Centre, separated the group from the outside world, giving them a common bond, a real feeling of belonging to a community of their own.

In contrast to the self-images displayed at The Anarchy Centre, in Garry, Liz and Dave's private living environments objects they had transformed in some way, and which reinforced their own outlook, defined a capsule for them, in which they could hide and feel psychologically free.

Each of the work's three panels has been made by one of the group, the lower part representing their individual capsulised environments - the room in which they live - and the top part their common reference point - the social expression of their counter consciousness within the context of The Anarchy Centre.

'Escape With Us Into The Night'
October/December 1982.
Three panels each 140cm x 90cm.
Photographic prints, acrylic paint, ink, pencil, Letraset text and objects collected by Garry, Liz and Dave from their flats.

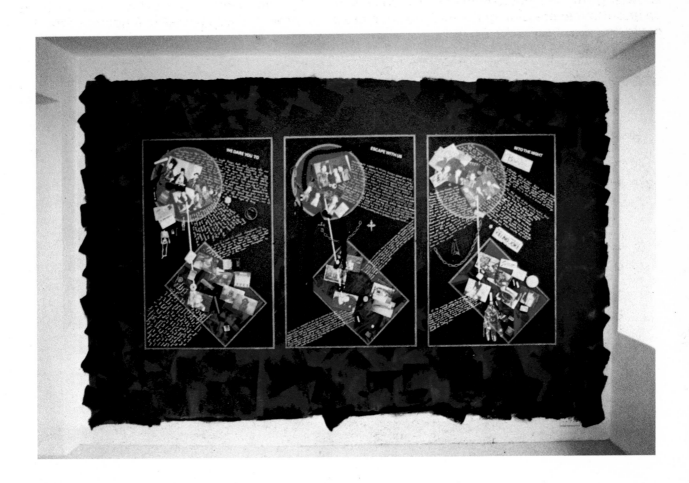

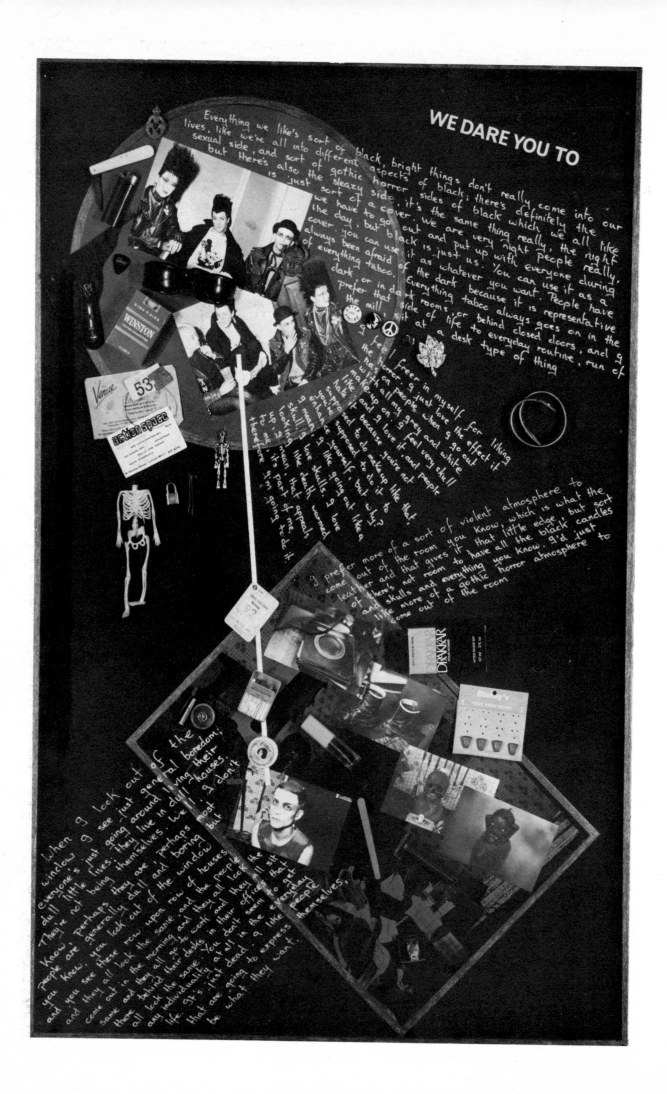

Everything we like's sort of black, bright things don't really come into our lives, like we're all into different aspects of black; there's definitely the sexual side, and sort of gothic horror side it's sides of black which we all like but there's also the sleazy side, it's the same thing really, the night is just sort of a cover. We are very night people really, we have to go out and put up with everyone during the day, but black is just us. You can use it as a cover, you can use it as whatever you want. People have always been afraid of everything because it is representative of everything dark or in dark. Everything tabco always goes on in the prefer that side of life to everyday routine, run of the mill sit at a desk type of thing

I feel freer in myself for liking the horror. I just love the effect it has on people when I go out with all my grey and white make up on, I feel very skull and I love it, and people like skulls because you're not supposed to do it, I mean that's why skull I like going out like that to me. If you like yourself but why look like death I love therefore it's part of me, I'm going to do it.

I prefer more of a sort of violent atmosphere to come out of the room you know, which is what the leather and that gives it that little edge; but sort of there's not room to have all the black candles and skulls and everything you know. I'd just like more of a gothic horror atmosphere to come out of the room

When I look out of the window I see just general boredom; everyone's just going around living their dull little lives, they live in dull houses. They're not being themselves, well. Perhaps most and you see these row upon row of houses and they are perhaps dull and boring but you all look the same and the people that sit come out in the morning and they all look the there behind their desks in their offices that same and they all go to work and they all sit all look the same. You don't seem to get any individuality at all in the everyday life, it's just dead, a like people that are going to express themselves, be what they want.

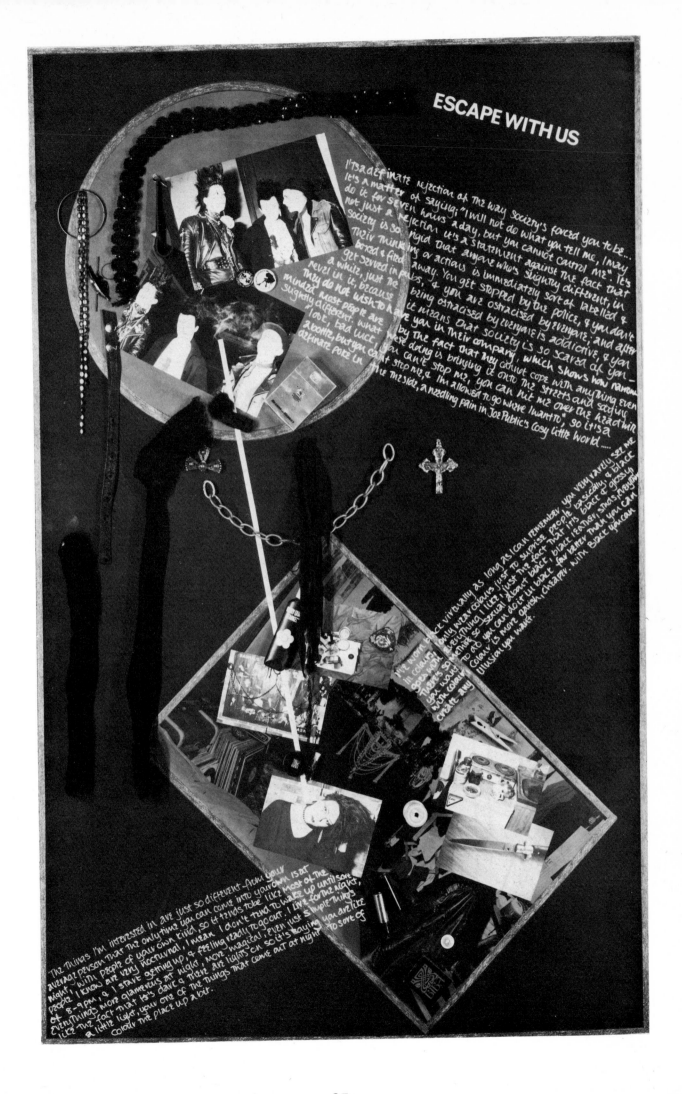

It's a definate rejection of the way society's forced you to be... It's a matter of saying, "I will not do what you tell me, I may do it for seven hours a day, but you cannot control me" It's not just a rejection it's a statement against the fact that society is so rigid that anyone who's slightly different, in their thinking or actions is immediately sort of labelled & bored & fired away. You get stopped by the police, & you don't get served in pubs, & you are ostracised by everyone, and after a while, just the fact that society is so scared at you — revel in it, because it means that they cannot cope with anything even slightly different. what you are doing is bringing it onto the streets and saying most people are minded, bad luck, I can't stop me, you can hit me over the head with a lot, bad luck, I can't stop me, I'm allowed to go where I want to, so it's a bottle, but you can't stop me, needling pain in Joe Public's cosy little world

We more black vividually as long as I can remember, you very rarely see me in colour, I only wear colours, just to suprise people, basically, a black goes with everything I like I just the fact that it's black & glossy. There's something so sexual about black, black leather, shads, mayhem you want to do you can do it in black, for better than you can work colour is more garish, cheaper, with black you can create any illusian you want.

The things I'm interested in are just so different from your average person that the only time you can come into your own is at night, with people of your own kind so it tends to be like most of the people I know are very nocturnal, I mean I don't tend to wake up until sort of 8–9pm, & I start getting up, & feeling ready to go out, I live for the night, everythings more glamerous at night, more magical, even just simple things like the fact that it's dark & there are lights on so it's saying you are like a little light, you are one of the things that come out at night to sort of colour the place up a bit.

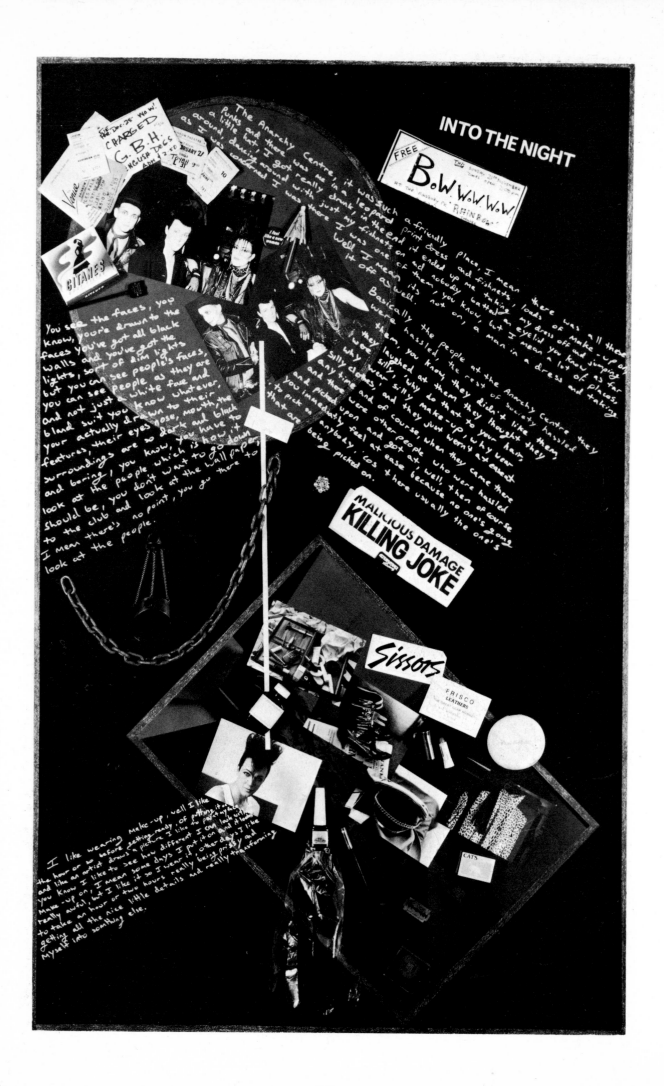

FREE
B.oW.WoW.WoW

MALICIOUS DAMAGE
KILLING JOKE

Sissors

FRISCO
LEATHERS

CATS

CHARGED
G.B.H.
ENGLISH DOGS

CITANES

The Anarchy Centre, it was such a friendly place, I mean there was all these Punks and there was me in a leopard print dress and fishnets / loads of make-up and a little but I got really drunk and nobody battered an eyelid you know, as far as I was dancing around / in the end it ended up me taking my dress off and jumping confined I was just my fishnets on and them / you know, but I mean a lot of places I was one of its not on / a man in a dress and taking it off as well. Well I mean

Basically the people at the Anarchy Centre they were hassled, the rest of society hassled them, you know they didn't like them, laughed at them / silly to that they thought they were silly / why do they wear silly make-up, why wear and they just worry about silly clowns and of course, when they came there, anything and other people who were hassled and they immediately felt at ease because no one's to pick on / well then of course they are being picked on. 'cos there usually the one's anybody.

You see the faces, you know, you're drawn to the faces you've got all black walls and you've got the dim lights, lights sort of the see peoples faces, but you can people as they are you can see white face and and not just your know whatever, bland suit you drawn to their your actually nose, mouth and black features, their eyes dark and black surroundings are so you have it and boring, you know, which is how it look at the people you don't want to go down should be, you don't want to look at the wallpaper to the club and look at there no point, you go there I mean there's look at the people.

I like wearing make-up, well I like the hour or so before getting ready, I of putting it on like an artist draws a picture I like to paint my face and know I like to see how different I can look with you on, I mean some days I put it on and I like make-up on / I like it so I wear it, other days I like really awful but I like it so really being fussy ad to take an hour or two hours details and really transforming getting all the nice little myself into something else.

'Tower Block Drawing No. 4
March 1984.
80cm x 130cm.
Photographic prints, ink, pencil, crayon on paper.

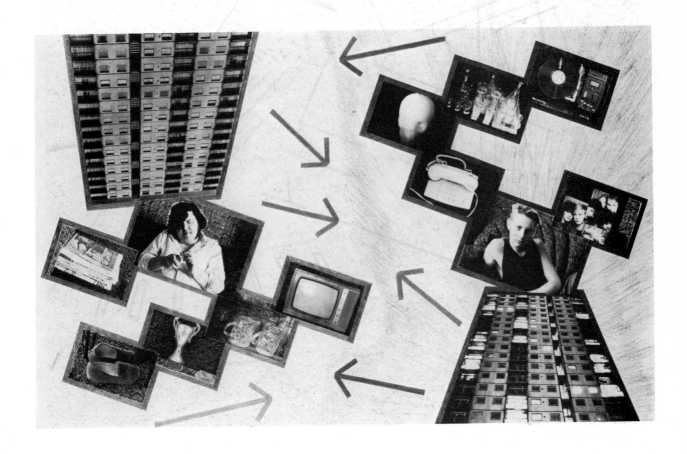

'MODEL DWELLINGS'

'Model Dwellings' was one of the group of four works that I made that centred on the creation of self-organised, private clubs by members of the night world in London, own that were their response to their social alienation. Each of the four clubs had quite different self images, being created for their own special community, and expressing counter consciousness through distinctly different codes and attitudes. My work, 'Model Dwellings', takes its name from the private club started by Pearl, who lived at the top of a tower block in Paddington, London.
The special identity of 'Model Dwellings' was built around Futurism, a projection into and out of the future, a synthesis of a variety of visual and musical cultural forms that had been brought together, and laying the beginnings of the more extreme, articulate manifestations of futurism that are presently a creative catalyst.

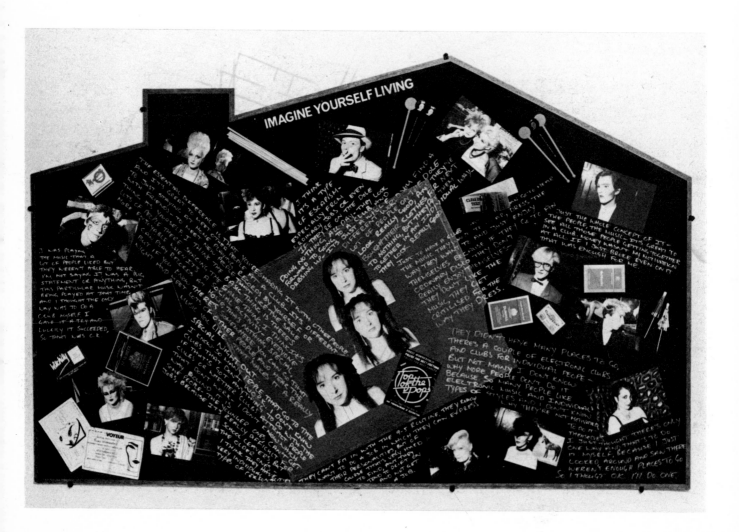

'Model Dwellings'
August/December 1982.
Two panels 90cm x 144cm.
Photographic prints, acrylic paint, ink, pencil, Letraset text, and objects collected by Pearl from her club
'Model Dwellings'.

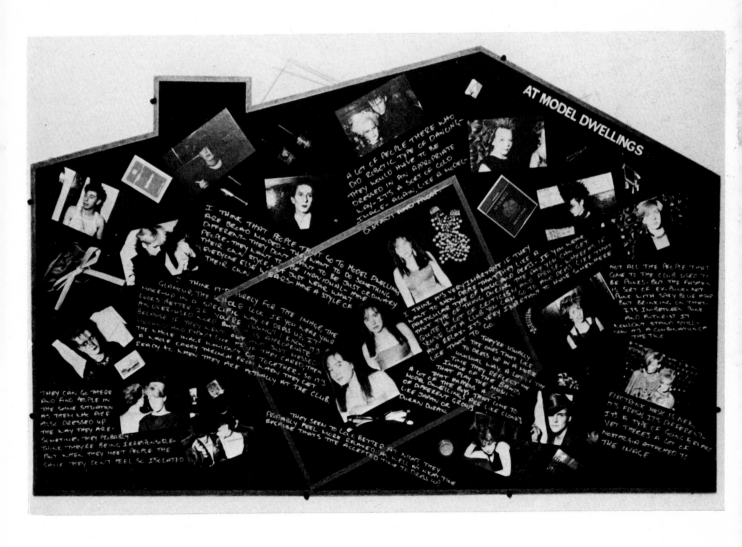

'Is There A Life After Dark?'
December 1982
131 cm x 97cm.
Photographic prints, acrylic paint, ink, pencil, Letraset text, and objects collected by Scarlett from her flat.

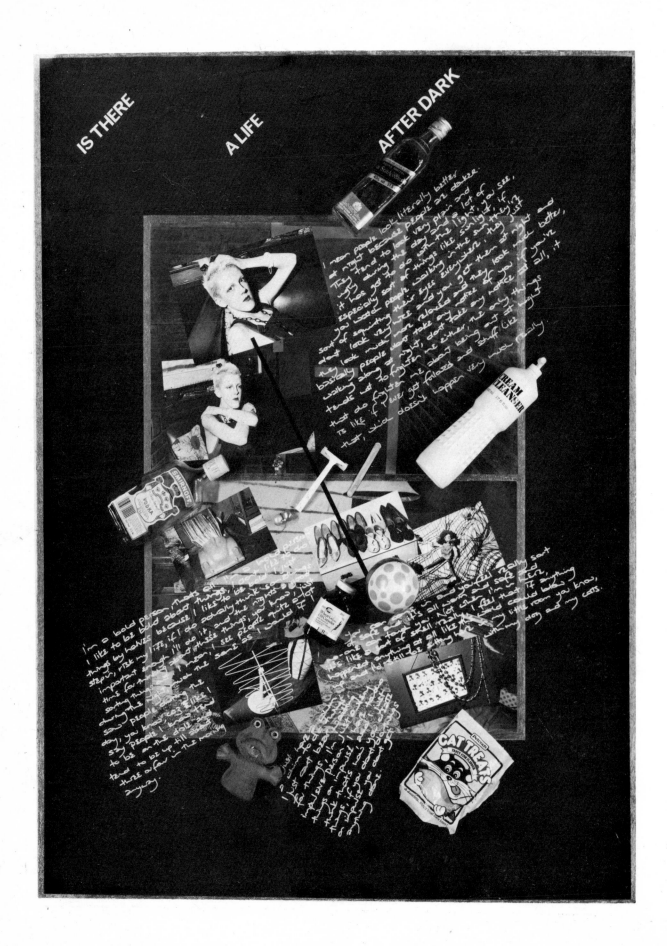